**HISTORY
FOR
PEACE
TRACTS**

How do we understand what was, grapple with
what is and prepare for what is likely to be,
as a nation, as a people, as a community,
as individuals?

This series is an attempt to address this question
by putting into print thoughts, ideas and concerns
of some of South Asia's most seminal thinkers.

In memory of Kozo Yamamura (1934–2017)

PARTITIONING BAZAAR ART

Popular Visual Culture of
India and Pakistan
around 1947

YOUSUF SAEED

LONDON NEW YORK CALCUTTA

The text in this volume is an updated edition of a lecture delivered at the 2016 History for Peace conference 'The Idea of Nationalism'.

Seagull Books, 2023

© Yousuf Saeed, 2023

First published in volume form by Seagull Books, 2023

ISBN 978 1 80309 291 1

British Library Cataloguing-in-Publication Data

A catalogue record for this book is available from the British Library

Typeset by Seagull Books, Calcutta, India

Printed and bound by WordsWorth India, New Delhi, India

CONTENTS

INTRODUCTION

South Asia's streets, public spaces and homes are filled with colourful, mass-produced popular images. From religious posters and those featuring movie stars to calendars, large billboards and roadside graffiti, all of it reflects the aesthetics of the masses who revere and celebrate them. Most of these were hand-painted illustrations with rich colours and decorative motifs in a style often called the Bazaar or calendar art. While religious iconography, such as that of

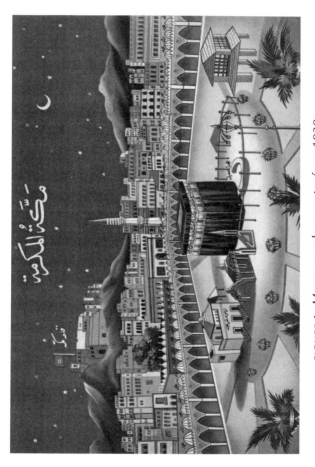

FIGURE 1. *Macca*, a colour poster from 1930s.

Hindu gods and goddesses dominates much of this visual universe, images with Islamic themes, with typical depictions of Mecca, Medina and the local Sufi shrines, are not too far behind.[1] Some scholars studying Indian art produced during the colonial period have shown how the concept of nationalism, dominated by Hindu revivalist themes, was entrenched among Indian masses through the use of popular prints.[2] However, while Hindu images seem to easily adapt to political themes—as is the case with Bharat Mata (Mother India), revered both as a religious and nationalistic icon[3]—one finds very little political content in Muslim poster art—it mostly comprises visuals of piety, or at the most, nostalgia for a decaying Muslim aristocracy (see figure 1).

Does this mean that Indian Muslims did not engage with political themes worthy of being depicted visually? Or is this a prejudiced representation of the community as being apolitical and pious? Some would even suggest that the religiosity of Muslims was not compatible with Indian nationalism, at least visually, except in the case of their presence in the clichéd images of 'national integration'. Since the creation of Pakistan in 1947 the loyalty of Muslims in India towards their homeland has always been a subject of debate, even discussed in popular media such as cinema, television and radio, in addition to calendar art. For this reason, it would be worthwhile to explore the representation of political themes in Muslim art before and after 1947, especially through what has been produced by the popular visual culture of Pakistan.

The spread of the printing press in India in nineteenth century triggered the production of literatures that exclusively addressed Hindu or Muslim readers, helping them formalize and often institutionalize their distinct identities.[4] These texts give us the impression that, as the Mughal Empire was falling apart, Muslims suddenly realized that they were in a dar-al harb (a land where Muslim law doesn't 'apply),[5] whereas Hindus discovered a desire to return to or recreate what they saw as their utopian Vedic past. On occasion, the same publisher catered to

both identities. Such polarization crept its way into popular art too. To further understand this, it is important to identify the themes (and their prevalence) that were depicted in Muslim calendars before and after 1947, a watershed moment for North India's popular print culture.

There are many examples that illustrate the political leanings of early calendar art. Indian calendar makers in the early-twentieth century used to print visual catalogues for clients who wished to buy customized calendars with their specific branding. These large colourful catalogues from the 1930–60s—some of which were surveyed in the private collection of Priya Paul in Delhi—have a historical value in that they reveal popular trends through the customers' preferences (see figure 2).

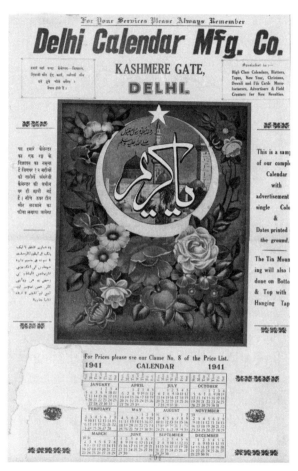

FIGURE 2. A 1941 calendar illustrated with an Islamic image.

Catalogues of the then-well-known companies such as All India Calendar Co., Oriental Calendar Mfg Co., Ajanta Art Calendar Mfg Co., Empire Calendar Mfg Co. (all from Calcutta) and Imperial Calendar Mfg Co. (from Delhi) feature images belonging to the themes listed in table 1.[6]

As the data shows, images with Hindu religious themes or patriotic icons (and very often a potent mix of the two) grew in number after 1947, while images with Muslim themes, which were in any case disproportionately low given the percentage of Muslim customers, further decreased after the Partition. Despite its limitations, this short survey does compel us to ask a pertinent question: are Islamic images incompatible with Indian nationalism or, for that matter, do they evade any politicization? To explore this further, we need to go beyond this set of

TABLE 1.

Theme	Relative prevalence (%) in catalogues from:	
	1930–1947	1948–1965
Hindu deities, mythology	33	35
National leaders, freedom fighters, patriotic icons	21	25
Film actresses, beautiful women, cute babies	16	17
Natural scenes	7	6
British Raj, viceroys, the Queen	6	3
Modern times, industrialization	5	7
Muslim religious themes	4	1
Indian kings, aristocracy	2	1
Others, miscellaneous	6	5

visuals and examine the political content of Hindu popular art during this period. It is important to note that there are some features one should avoid associating with a religious identity, such as the widespread use of the Urdu language in mainstream print culture before the 1950s—even the Arya Samaj, a Hindu reform movement, used Urdu for its propaganda literature—or slotting the images of leaders like Gandhi, Nehru and Maulana Azad according to their religious identity.

The evident connections between Hindu identity and Indian nationalism have been copiously explored by scholars such as Christopher Pinney,[7] Lawrence Babb,[8] Sumathi Ramaswamy[9] among others. Rather than repeating them here, I would like to describe a couple of visual tropes to extend my argument. It is well known that both Hindus and Muslims made equal and often combined efforts in

the struggle for India's freedom from the British. In fact, in some cases, Muslim individuals and institutions initiated independent local efforts to protest against the British Raj.[10] Popular calendar art of the early-twentieth century certainly oversimplified the history of this struggle by making heroes of only a handful of prominent freedom fighters such as Mahatma Gandhi, Jawaharlal Nehru, Subhash Chandra Bose, Bhagat Singh, Chandrashekhar Azad, Sardar Patel, Sarojini Naidu, Rajendra Prasad and a few others, ignoring the equally complex struggles of many other leaders (see figure 3). Most of the visually celebrated leaders belonged to the Indian National Congress—Gandhi and Nehru alone feature on more than half of all such images. Many of these leaders have been depicted along with the map of India or the icon of Bharat Mata.

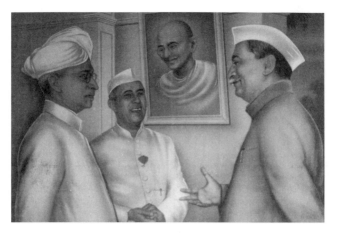

FIGURE 3. *Three Leaders* (*c.*1940). (*From the left*)
S. Radhakrishnan, Jawaharlal Nehru, a framed image of
Mahatama Gandhi and Rajendra Prasad.

Maulana Abul Kalam Azad—the
prominent Muslim member of Congress who
refused to migrate to Pakistan—is shown in
only a few individual portraits but hardly as
part of the Indian map and never along with
Bharat Mata (see figure 4).

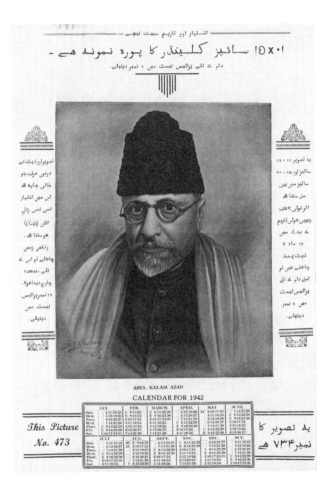

FIGURE 4. A sample calendar image featuring Maulana Azad.

He also appears along with Jinnah and Gandhi in a popular print depicting a meeting with the viceroy Lord Wavell in Shimla (figure 5). Another calendar illustrating the Shimla Conference of 1945, where Wavell tried to discuss in vain the reconstitution of the Executive Council, includes many Muslim leaders, among them Khwaja Sir Nizamuddin, Nawabzada Liaquat Ali Khan and Hidayatullah Ghulam Hussain.[11] But these images of meetings and conferences do not romanticize or glorify these figures, rather they serve more of a factual or indexical purpose, produced to illustrate contemporary incidents and sold in the market as stand-alone pieces. A curious example of such factual pictures is a 1949 colour poster, signed by artist Das Gupto, showing the funeral

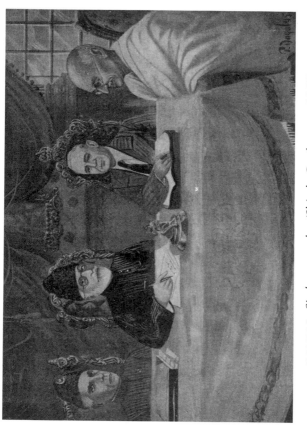

FIGURE 5. *Simla sammelan* (Shimla Conference, 1945).

procession of M.A. Jinnah in Pakistan (see figure 6). While several minor events of the freedom movement have been illustrated through posters and postcards, one finds none illustrating for instance the Khilafat Movement, a major campaign started by Muslim leaders to buttress a collapsing Ottoman Empire after the World War I—even though Gandhi supported it and benefited from it in his cause of Hindu–Muslim unity. However, Muslim sentiments about the Khilafat movement found expression in Urdu texts published in Calcutta and elsewhere.

Prominent Muslim freedom fighters or reformers, such as Sir Syed Ahmed Khan, Hakeem Ajmal Khan, Dr Mukhtar Ahmed Ansari, Maulana Shaukat Ali, Mohammad Ali Jauhar, Mohammad Iqbal, Khan Abdul Ghaffar Khan, Dr Zakir Hussain and Saifuddin Kichlew, are all absent in these

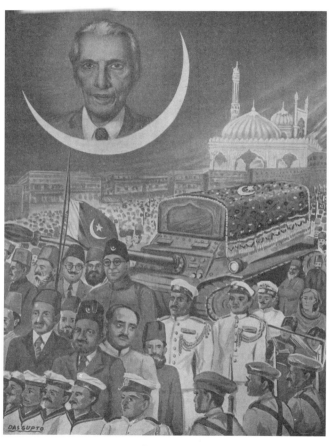

FIGURE 6. *Qaid-e Azam ka akhri safar*
(The last journey of the Great Leader)
by Das Gupto (1949).

patriotic images. Even earlier Muslim icons like Tipu Sultan (considered by some as India's first nationalist) or Bahadurshah Zafar (who initiated an uprising against the British) are not nearly as represented as other legendary figures like Rani Lakshmi Bai, Rana Pratap or Chatrapati Shivaji. One exception is Abbas Tayebji, a Bohra Muslim associate of Gandhi from Gujarat, who is shown working on a charkha (spinning wheel) in what is either a postcard or a small poster. Captain Shahnawaz Khan is shown once in a 1946 calendar depicting other brave Indian soldiers who fought against the British. A small portrait of Ashfaqullah Khan features at the bottom of a 1931 poster depicting the martyrs Bhagat Singh, Azad, Ramprasad and others, but never when the latter are shown offering their decapitated heads to Bharat Mata in many other illustrations.

But these minor representations of Muslim leaders seem trivial when compared to those of the mainstream Hindu leaders, typically shown around a map of India. In many posters Bharat Mata, and sometimes Lord Vishnu himself, is shown blessing Nehru and Gandhi (see figure 7). Often, one can plainly see that images of Hindu icons have been recycled by substituting the deity's face with that of a political leader like Gandhi. The contours of the Indian map itself are such that they can easily adapt to the image of a sari-clad woman—Bharat Mata, frequently illustrated as a Hindu deity.[12] More interesting and problematic are the images deliberately trying to represent the role of religions other than Hinduism in the making of modern India.

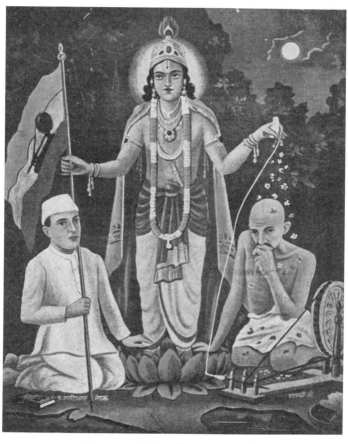

FIGURE 7. Nehru and Gandhi sitting on the contours
of the Indian map, blessed by Lord Vishnu,
in a calendar image from c. 1940.

A poster titled *Message of Love* (figure 8) shows Bharat Mata flanked by religious as well as political leaders. However, there is no representation of Islam or Muslims.

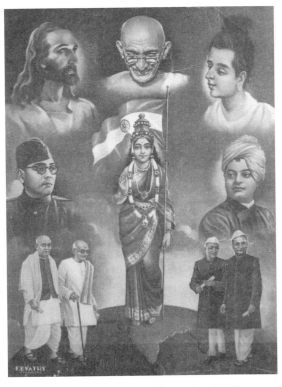

FIGURE 8. *Message of Love* (c. 1940).

Another image titled *Agriculture* from a calendar catalogue shows Christ, Gandhi and Buddha blessing a scene of Indian farmers with a tractor and a plough while Rajendra Prasad, Nehru and Patel look on. One must bear in mind that in such instances even if the artist did wish to depict Islam, there was no human personality or religious icon he could visually represent as a symbol of the religion. But this could also be a convenient excuse to exclude Islam.

These printed images also reflect the supposed all-inclusiveness of Hinduism— all faiths coming under its umbrella except Islam. An image titled *Prajatantra* (Democracy) (figure 9) from the same catalogue shows the trio of Christ, Gandhi and Buddha looking from above the clouds upon a queue of marching Indians who seem to represent, from their attire,

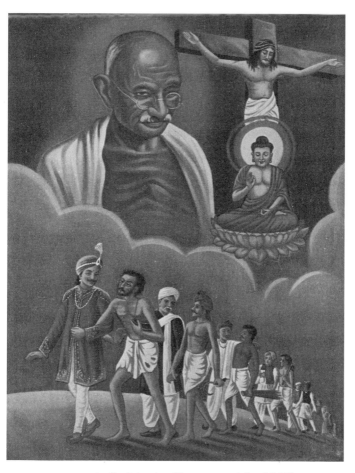

FIGURE 9. *Prajatantra* (Democracy) (*c.* 1940).

antithetical male pairs of king and pauper, farmer and learned man, low-caste and high-caste and so on. Only towards the diminishing end of the queue one can spot a person dressed probably as a Muslim; women come at an even farther diminishing point of the queue—a sort of a patronising effort to depict egalitarianism, yet the biases are apparent. To further explore such attitudes of the 1950s, it would be interesting to study other forms of popular culture such as Hindi cinema or its music to see how different religious identities have been represented in the portrayal of freedom struggle. A recent author for instance points out how 'Mere desh ki dharti' (The earth of my land), a patriotic film song from 1967 still popular today, mentioned only a few mainstream leaders and excluded many popular ones (especially non-Brahmins and Muslims).

The lyrics try to associate the key colours of the Indian flag with the names of some freedom fighters but in an oddly selective and biased way.[13]

Later political images did represent Muslims and Islam but only to situate with other religions in the Nehruvian project of 'national integration'—a concept often defined as the adoption of a blend of many religious identities necessary for a peaceful co-existence in a multi-religious land. There is at least one factual postcard from the 1940s that illustrates how the death of one Ganesh Shankar Vidyarthi in a Hindu–Muslim riot in Kanpur had a heart-rending effect on the people of the town, thus leading to further unity among them. But post-1950s most calendar images of this category show children wearing the Hindu, Muslim, Sikh and Christian headgears, often with the generic title

Hum sab ek hain (We are all one).[14] In one poster Gandhi is shown meditating under a tree while his backdrop has the silhouetted icons of a Hindu temple, a mosque, a church and a Sikh gurudwara. Educational poster-charts used in Indian schools attempted to creatively represent the diversity of Indian cultures and religions. But even here the artist was challenged in some ways to keep the supposed Muslim sensitivities about images at bay.

The project of national integration could not go beyond the poster competitions and exhibitions in a few schools. However, themes of communal harmony and Hindu–Muslim unity did find more extensive representation in popular cinema, theatre, music and literature, some even becoming 'superhits'. But their effect on popular calendar art has

been negligible. In contrast, some adverse propaganda fanning religious and ethnic divisions thrived in print publications. The Hindu revivalist movement in the nineteenth century promoted for instance the protection of the cow as the sacred mother of Hindus through the images of *chaurasi devtaon wali gai* (the cow containing 84 Hindu deities within). Some initial printed versions of this image had shown a Muslim butcher raising a sword above the cow but being stopped by Dharmaraj. The butcher in the later posters was replaced by a carnivorous demon of *kalyug* after some Muslims were reported to have objected to it. Some versions also showed a Muslim, a Parsi and a European being given the cow's milk to drink, with the caption: 'Drink milk and protect the cow.'

More recently, the religious campaigns of the twentieth century such as that of the Ram Janmabhoomi (claiming that ord Rama's birthplace in Ayodhya was destroyed by the Mughal emperor Babur in sixteenth century to construct a mosque, and hence it needs to be recaptured by Hindus) translated into posters, literature and videos of hate against Muslims.[15] Some Hindu nationalist organizations have been producing a body of printed images such as greeting cards for New Year's Day or Diwali that depict Bharat Mata sounding the alarm about alien cultural domination, i.e. Westernization, Christianity and Islam.[16] In these cards Muslims and Christians are often shown as anti-national barbarians—demons destroying Bharat Mata or committing other similar acts of sacrilege. But these images belong to a different political

stream and should not be seen as related to the Independence movement.

Indian Muslims continued to express their political aspirations after 1947 through a number of Urdu newspapers and tabloids, many of them illustrated. While Urdu magazines and 'digests' provided some links to the larger Muslim world with stories on the topics of Pakistan, Saudi Arabia and Palestine etc., they also complained against the perpetual communal riots and the rise of Hindu prejudice against Muslims in India in bold and often rabble-rousing headlines. But such political content never entered the comfort zone of calendar images, the way the Hindu display posters had. However, the one type of printed images that may have provided a popular feel-good factor of belonging among Indian Muslims was that of calendar images showing

community-based stereotypes. When a poster artist explored subjects to produce a new Islamic image, or to make innovative variations of Mecca and Medina, the first thing he recalled (in the absence of any deities) were the clichéd images of Muslim piety—girls with headscarves reading the Qur'an, innocent-looking boys in skullcaps hugging one another after the Eid prayers, and pious young women with raised hands from which a translucent dupatta cascades down, stereotypes that were even used in popular Indian cinema.[17]

The examples above indicate that the very seeds of Indian nationalism sown in the popular imagination through printed images were rather biased and not representative of the region's wide cultural and religious diversity.

POPULAR VISUAL CULTURE IN PAKISTAN

While the impact of the Partition on Muslim popular art needs to be studied in greater detail, I would first like to share some experiences from my limited sojourn in Pakistan in 2005.[18] Most Indians or non-Pakistanis see Pakistan as a land of Muslim fundamentalists and steadfast Wahhabis running an Islamic state that strictly abstains from anything non-Islamic or non-Shari'a. Outsiders take it for granted that present-day Pakistan would not have any traces of a Hindu or syncretic past since it was born out of the two-nation theory, which assumed that Hindus

and Muslims of the subcontinent were two separate political entities and could not co-exist. Doubtless, the orthodox and reformist institutions and individuals have always remained in a powerful position in Pakistan, trying unremittingly to redefine or dictate the cultural identity of Pakistanis according to the Islamic tenets. But their efforts of over seven decades have neither yielded a definitive national identity of Pakistan nor have they been able to culturally alienate the entire society according to their terms. Although as a result of this process of 'Islamization' in the 1980s, the religious extremism and its consequent violence has certainly grown into a monster in Pakistan. Equally prominent, however, has been a thriving culture of popular Islam represented by Sufi shrines, syncretic rituals and a vibrant print

culture of devotional art and literature, which in its figurative iconography crosses many limits that even India's Islamic images have been reluctant about. Even a cursory look at the representations in the poster art of Pakistan can reveal a popular visual imagination that has been running parallel, or sometimes contrary, to the very idea of Pakistan as a nation.

Almost all Sufi orders and shrines dotting the landscape of Pakistan are in a continuum with those in India—in fact the Sufis coming from central Asia had to cross the region which is now Pakistan, to arrive in the region which is now India, and many of them settled in places like Multan, Lahore and other towns of Sindh and Punjab, resulting in the emergence of a rich Sufi literature and music.[19] While Lahore and Punjab are

famous for saints like Ali Hujweri (Data Ganj Baksh), Baba Farid Shakar Ganj, Baba Bulleh Shah, Khwaja Ghulam Farid, Baba Shah Jamal, Barri Imam, Pir Mehr Ali, Sakhi Sarwar and others, Sindh and Multan have famous saints such as Abdullah Shah Ghazi, Shahbaz Qalandar, Rukn-e Alam, Shah Abul Latif Bhitai, Bahauddin Zakariya, Sultan Bahu and many more (see figure 10). Their historical significance as well as contemporary popularity has been extensively studied and documented by scholars such as Annemarie Schimmel, Richard Eaton, Carl Ernst, Wasim Frembgen[20] and several other Indian and Pakistani scholars.

What would surely surprise any Indian visiting Pakistan is the cultic hysteria among the crowds of devotees at many religious sites, especially on certain auspicious days of the week. The Thursday

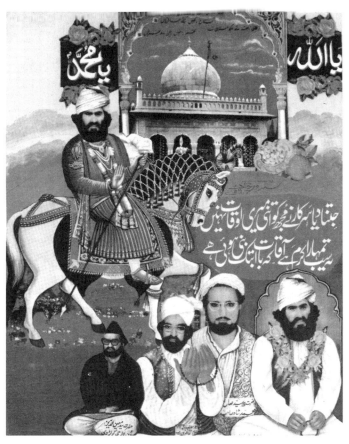

FIGURE 10. A poster showing photographic portraits of
the shrine keepers related to the saint Mehr Ali
of Golra Sharif (near Islamabad) in Pakistan.

nights or the urs' of saints are great occasions of folk rituals, chanting and celebration. In fact, observing the celebration of any festival, especially in a town like Lahore, is quite an eye-opener for an Indian Muslim. Each of the three major festive periods—Basant, Eid-e Miladun Nabi (the Prophet's birth anniversary) and Independence Day (14 August) that I witnessed in Lahore amazed me for their exuberance, colours, sounds and the spirit of people, comparable to the celebration of Diwali or Holi in India. Basant, the spring festival in Lahore, famous for kite-flying, food and music, has recently been discouraged—at least the kite-flying has been banned (due to many fatal accidents) by the local government as well as the clergy who declared it un-Islamic.[21] But the festive spirit of Lahore's residents does not let it die.

On Eid-e Miladun Nabi, Lahore's children make hundreds of miniature replicas on pavements outside their homes depicting events from the Prophet's life, including the shrines of Mecca, Medina and the cave of Hira (where the Prophet received revelations from Gabriel), often using common household items and toys like Barbie dolls and GI Joes! Even adults make fine and expensive paper models of the Medina mosque and the Ka'ba, exhibiting them on Lahore's streets with pride.[22] There are public gatherings on every street at night—blocking all the traffic—involving recitations of milads (religious orations), comparable again to Hindu jagrans (night-long singing and prayers) in India. Cauldrons of food are cooked and distributed as part of such occasions. Many of these festive gatherings happen to be in and around takias or

baithaks (shrines) of saints, where qawwals and other musicians also perform. In fact, the practice of traditional music with its rich syncretic components, especially its lyrics and the musical modes, has mostly survived in Pakistan, despite many efforts to mute or alter it to suit 'Islamic' identity.[23]

Punjab and Sindh were home to several saints revered by Hindus, Muslims and Sikhs alike, with folklore about their miraculous powers being shared across different communities and sects, often even the same legend and iconography being attributed to more than one saint. An image of a turbaned and bearded saint squatting on a lotus atop a fish in a pond or river has been referred to by Sindhi Hindus as the river deity Jhoole Lal, by Muslims as Prophet Hazrat Khidr, and some even consider

him a Sikh guru. Thus, a recent poster of Khidr published in Lahore (figure 11) depicts the same icon used to represent Jhoole Lal, except for the cut-outs of the Qur'an and the Mecca–Medina shrines pasted on top. It is amazing to see how such an openly pantheistic visual culture, including dargah rituals and festivities, is allowed to thrive in a country that is also home to some of the most steadfast and powerful Wahhabi Muslims.

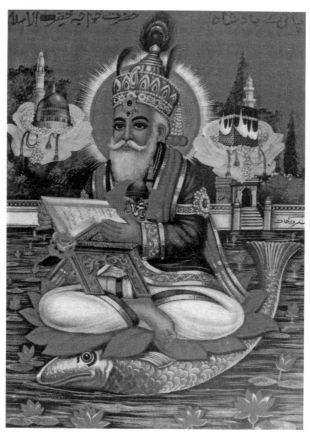

FIGURE 11. *Pani ke badshah Hazrat Khwaja Khizr*
(c. 2004) by Sarwar Khan. Portrait of Islam's mythical
Prophet Khizr, an image reconstructed from
a poster of the Hindu deity Jhule Lal of Sindh.

SUFI POSTERS IN PAKISTAN

The unhindered depiction of Sufi saints in the thriving poster industry of Pakistan is the most surprising aspect of its visual print culture. Some saint portraits do exist in India, but Indian publishers have generally been reluctant in depicting Muslim saints. In fact, many Indian Muslims would probably consider it blasphemous to see portraits of saints like Moinuddin Chishti, Nizamuddin Aulia or others which are available freely across the border. Pakistani poster artists, however, have not only painted figurative portraits of all South Asian saints but

also their miracles and attributes in vivid realism. An Indian had to go to Pakistan to see what Indian saints such as Moinuddin Chishti, Sabir Pak Kaliyari, Shah Mina or Abdul Qadir Jeelani looked like (see figure 12)! I could even find the portraits of Hazrat Ali, Imam Hasan, Hussain and other personalities revered by the Shi'a, freely available in Lahore—although probably imported from Iran.

Many such collages depicting the saints include photographs of the shrine's current khadims or keepers and their male family members (even children) to keep their image alive in the public memory. Some of the current shrine keepers in rural Pakistan are also politically influential landowners, retaining a spiritual as well as temporal influence over the populace. New

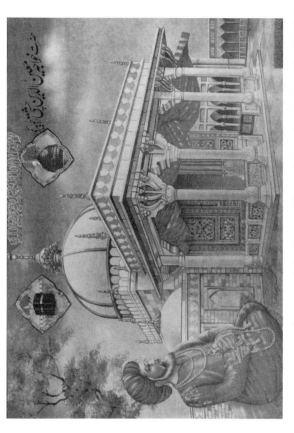

FIGURE 12. A popular portrait by Sarwar Khan of the saint Moinuddin Chishti along with his shrine, produced in Lahore (c. 2004).

photographs continue to be pasted along with cut outs of tigers and lions to invoke a sense of fear and power of the saint among the devotees. At some shrines, such as that of Pir Mehr Ali at Golra near Islamabad, photographs of the khadims not only appear on posters but also on equally colourful visiting cards freely distributed to all pilgrims. One can buy on Lahore's streets small matchbox-sized images of saints and Shi'a symbols, laminated in plastic, often used to hang in the dashboard of auto-rickshaws or taxis.

A well-known folk art form that blends with religious iconography is Pakistan's truck art. Owners spend a fortune getting their vehicles painted in a riot of colours and designs, including religious symbols like the Ka'ba and Medina's green dome.[24] Some of these

trucks, mostly coming from the northwest of the country, are like moving galleries or museums of popular art, often depicting romantic tales of the pathans. Their art can also be compared with the popular paintings on the cycle rickshaws of Bangladesh, which similarly depict Muslim religious themes in colourful folk style besides romantic and now modern legends.[25] While the popular art of Pakistani trucks or Bangladeshi rickshaws cannot be termed Islamic—these are more specific to local culture and might have thrived even if there was no partition of India—one can spot in them a hint of national symbolism along with religious icons.

MIXING POLITICAL WITH THE RELIGIOUS

Pakistani religious images are also not devoid of political content, often carrying portraits of local leaders. Popular images and billboards of Mohammad Ali Jinnah, Liaqat Ali, General Zia-ul-Haq, Zulfiqar Ali Bhutto and the like have thrived on Pakistani streets in the past. In fact, earlier posters published in Lahore have also depicted Islamic heroes like Salahuddin Ayyubi (known in the West as Saladin) or the Indian ruler Tipu Sultan, both depicted along with cut-outs of European looking

soldiers being defeated or killed by them. Many older posters show Zia-ul-Haq as a martyr or a pious Muslim praying before the Ka'ba or the Prophet's mausoleum, while Jinnah, General Ayyub and others look on. One cut-out pastiche shows Zulfiqar Bhutto in action with a bloodied dagger in hand, and his smiling daughter Benazir in a combat dress, holding a rifle. A caption in Urdu says: *Hum Kashmir ke liye hazar saal tak ladenge* (we'll fight for Kashmir for a thousand years). But the top half of this poster shows a lion (usually meant to signify Hazrat Ali) tending an injured deer (which probably means Kashmir).

Many of these posters also include warplanes, tanks and marching Pakistani soldiers, often women or

children, as visual fillers to signify the two wars that Pakistan fought with India.[26] Political posters of the later periods—covering the end of Zia-ul Haq's regime, Nawaz Sharif's government and the rise of Benazir Bhutto—have been explored in a study by Iftikhar Dadi who has shown how such leaders acquired a pious image placed amidst religious icons (see figure 13).[27] An image of the praying Benazir with her husband Asif Zardari and children, under Mecca, Medina and flying doves, signifies an ideal Pakistani family.

Sifting through a few old political posters produced in Pakistan, I found a surprise—a reaction to the 1992 demolition of the Babri Masjid in Ayodhya, India. The vertical poster

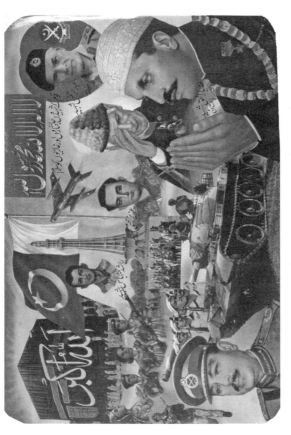

FIGURE 13. A popular poster (c. 1990) showing famous Pakistani political and religious leaders.

(figure 14), a photo–painting collage, shows the three domes of the Babri Masjid below which some supposedly Hindu 'activists' (some wearing saffron) break down a lower structure with sticks and pickaxes, with a couple of Indian policemen as silent spectators. A photo at the bottom shows an agitating crowd and a text in Urdu that translates to 'Agitate, agitate, agitate, the martyrdom of the Babri Masjid.' Another quotation from the Qur'an on top assures that the mosques belong to Allah, and 'do not involve other [deities] while invoking Allah.'[28] Besides Kashmir and Ayodhya the other international political subjects that occasionally crop up in Pakistani posters are the Muslims' struggles in Palestine, Bosnia, Chechnya, Iraq and similar conflict zones.

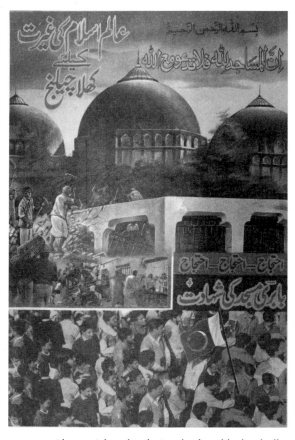

FIGURE 14. *Alam-e Islam ki ghairat ke liye khula challenge*
(An open challenge to the honour of the Muslim world)
(*c.* 1990), a Pakistani poster printed to protest
the demolition of Babri Masjid in India.

The walls of Pakistani city streets are shrouded with graffiti reflecting the unpleasant conflicts within different sects and factions of Islam, visible most dominantly in Karachi—the hotbed of sectarian violence for many decades. Almost everyone is fighting everyone and expressing their creative angst on the walls. The scathing slogans of religious factions also share space on the walls with ethnic rivalries, such as non-Punjabis cursing the Punjabi, Muhajirs (migrant) berating the Sindhi, and almost everyone denouncing America and Israel. The bitter violence ensuing out of such ideological differences in recent times has left Pakistani society gasping for life, worst affected being the individuals and institutions of cultural minorities like Sufis, Shi'as and Ahmadiyas.

In the region that became West Pakistan, Lahore and Karachi had been the major centres of printing even before 1947. North India's most prolific poster producer, Brijbasi, had a sprawling business on Karachi's Bunder Road— their 1930 colour posters were even printed in Germany.[29] But Punjab's Lahore and Amritsar had an older and more bazaar-based tradition of printmaking and lithography starting in the nineteenth century, comparable to Calcutta's print culture of the same time. In fact, Lahore had hundreds of talented

designers, painters, calligraphists, bookbinders, and later, engravers and printers even before the arrival of Maharaja Ranjit Singh (d. 1839), some of their art and skills still being bequeathed today.[30]

For instance, one finds a Hindu religious chromolithograph printed by Kirpa Ram engraver of Anarkali, Lahore, showing a devotee Dhyanu Bhagat presenting his severed head to goddess Durga, with a title and lines of Punjabi poetry in Urdu script, probably dated c. 1930. Further pre-1947 religious as well as nationalistic colour posters were published (with Urdu titles and bylines) by other Punjab publishers like Pandit Ram Saran (Firozpur), Mehta Halftone Co. and Aror Bans Press, the latter two being block makers and publishers from Lahore.

A 1930 Urdu advertisement of the Aror Bans Press, a business that started around 1882, is titled *Dharmik tasveeren* (religious images) (figure 15) informing the readers that 'if they wish to decorate their homes with the pictures of Lord Rama, Krishna and other deities and brave leaders, they must buy the pictures made by the Aror Bans Press, Anarkali, Lahore'.

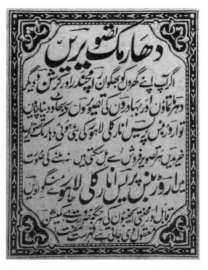

FIGURE 15. *Dharmik tasveeren*. Printed in *Aalamgir* (1930).

In 1947, the family's scion, Anand Prakash Bajaj, shifted the business to Delhi and in a few decades started *Mayapuri*, a popular film magazine in Hindi, besides a children's comic magazine *Lotpot*.[31]

There were direct and prolific business relations between cities like Lahore and Delhi, or Karachi and Bombay until 1947, including products of printing presses such as books, calendars and posters, manufactured in one town and distributed in another. For instance, Lahore's Aror Bans Press was also the distributing agent of Delhi's Imperial calendar company and so on. While a poster with Qura'nic calligraphy produced by the Taj Company of Lahore got sold and put up in a house in Meerut (Uttar Pradesh), an Islamic poster from

1940s published by Hemchandar Bhargava of Delhi (actually printed in Bombay) got distributed all over India by Hafiz Qamrud Din & Sons of Mochi darwaza, Lahore, who appear to have been prominent booksellers and poster makers.

A large number of Hindu publishers of Lahore produced Hindu religious books such as *Ramayana*, *Mahabharata*, *Hanuman Chalisa* and others in Urdu which were distributed in the rest of North India.[32] Jantaris—almanacs (also known by Hindus as panchang or kal-nirnai) which contain horoscopes, astrologically calculated suitable dates and timings to start important daily chores, according to the Hindu as well as the Hijri calendars—were also a popular item. Pandit Girdhari Lal Munajjim of

Sialkot (now in Pakistan) began publishing his *Mashhur-e Alam Jantari* in Urdu in 1896, which turned into a flourishing business that was brought to Delhi by his son and grandson in 1947 and continues to be published a century later in chaste Urdu, with a countrywide distribution.

Even though the partition of Punjab and western India have been the focus of this essay, one should not ignore the simultaneous partition of Bengal in 1947 and its impact on popular visual culture. For instance, Dhaka was a thriving centre of print and book publishing which got disrupted by the Partition.[33] Like Pakistan, Bangladesh too had a thriving culture of Sufi shrines, local holy festivals, folk devotional music and popular visual arts that continued to

remain in vogue even after the political events of 1947 and 1971.

Among the popular printed ephemera that circulated between South Asian cities later separated by the Partition were greeting cards for festivals like the Eid-ul Fitr. Lahore and Bombay were the centres of production of such picture cards that Muslim families sent by post to friends and well-wishers every Eid. While the earliest Eid cards carried images imported from Europe—even Christmas cards were recycled for Eid by stamping *Eid mubarak* in Urdu over them—later Eid cards featured specifically Islamic or Indo-Islamic iconography and Urdu poetry (see figure 16).[34] Many examples of such cards from 1930–1950s (for instance in the Priya Paul Collection of Popular Art)

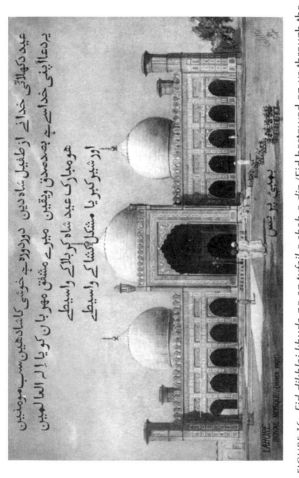

عید دکھلائی خدا نے از طفیل شاہ دین

FIGURE 16. *Eid dikhlai khuda ne az tufail-e shah-e din* (Eid bestowed on us through the King of faith the Prophet Muhammad) (c. 1930). Depicts the Badshahi Mosque, Lahore.

reveal a heavy postal traffic between Delhi, Lahore and Bombay (besides other towns like Lucknow, Karachi, Calcutta, Rangoon, etc.). Many popular Urdu periodicals published from the late-nineteenth century onwards from Lahore and Delhi had a large circulation on either side. They also carried advertisements of commercial products and brands that catered to a wide region all over South Asia.[35] The Partition obviously disrupted the circulation of such ephemera as the postal networks were compromised after 1947.

The Partition led to the large-scale, unplanned and hurried migration of people to and fro various cities across the border. In the ensuing violence, arson and looting that accompanied it, several homes and shops were damaged or burnt, and people's belongings

devastated. The newly arriving migrants in cities like Delhi decided to sell furniture, valuables and other ephemera they found or looted from the homes of the evacuees. Since Delhi, Lahore, Hyderabad and Lucknow had seen better days of erudite culture and the arts during the Mughal and British periods, the volume and quality of such ephemera was so enormous that the junk dealers made fortunes trading it—a lot of which continued to be resold by collectors until recently. The Partition evacuee property also comprises printed material and images, especially posted envelopes, periodicals, advertisements, pamphlets and packing material, among other things. It is only recently that the value of such popular ephemera—not really considered 'antique art'—is increasing, allowing us to imagine the

flow of thoughts, messages, ideas and images across various cities in undivided South Asia. There have been efforts such as the creation of an online Partition archive[36] as well as a Partition museum[37] in Amritsar and Delhi, to preserve artifacts and oral histories. While much has been lost, if one still combs through the old chests and trunks lying in a dark corner of one's house, or maybe chance upon some fraying, yellowed pages, one just might find the forgotten remains of South Asia before the Partition.

NOTES

1 Yousuf Saeed, *Muslim Devotional Art in India* (New Delhi: Routledge, 2012/2019).

2 Partha Mitter, *Art and Nationalism in Colonial India, 1850–1922: Occidental Orientations* (New York: Cambridge University Press, 1995).

3 Erwin Neumayer and Christine Schelberger, *Bharat Mata, Calendar Art and India's Freedom Struggle* (Oxford: Oxford University Press, 2008).

4 See for instance: Alok Rai, *Hindi Nationalism* (Delhi: Orient Longman, 2007).

5 Literally, *dar al-harb* means a place of war, but it has been used to denote a non-Islamic land.

6 More than 500 images spread over 7 catalogues were surveyed for this, though

these average percentages do not reveal the actual ratio of images selected by customers.

7 Christopher Pinney, *Photos of the Gods: The Printed Image and Political Struggle in India* (London: Reaktion Books, 2004).

8 Lawrence A. Babb and Susan S. Wadley (eds), *Media and the Transformation of Religion in South Asia* (New Delhi: Motilal Banarsidass Publishers, 1997).

9 Sumathi Ramaswamy, *The Goddess and the Nation: Mapping Mother India* (Durham: Duke University Press, 2010).

10 See for instance: Satish Ganjoo, *Muslim Freedom Fighters of India*, 3 VOLS (Delhi: Anmol, 2002).

11 A 1946 calendar titled *When the Goal Was in Sight* published by Paul & Co., Lahore (artist: Shobha Singh), in the collection of Priya Paul, Delhi.

12 Ramaswamy, *Goddess and Nation*, p. 380.

13 Prashant Kadam, 'Looking Inward: (Imagi)nation without the Subaltern', *The Hindu*, 25 January 2009.

14 Patricia Uberoi, ' "Unity in Diversity?" Dilemmas of Nationhood in Indian Calendar', *Contributions to Indian Sociology* 36(1–2) (2002): 191–232.

15 Christiane Brosius, 'Hindutva intervisuality: Videos and the politics of representation', *Contributions to Indian Sociology* 36(1–2) (2002): 265–95.

16 Christiane Brosius, 'Celebrating More than the New Year: The Hindu Nationalist Greeting Cards' in Richard H. Davis (ed.), *Picturing the Nation: Iconographies of Modern India* (New Delhi: Orient Longman, 2007). An abridged but visually richer version of this essay is available online in *Tasveer Ghar*: https://bit.ly/3XwqtG9 (last accessed: 16 February 2023).

17 Yousuf Saeed, 'This Is What They Look Like: Stereotypes of Muslim Piety in Calendar Art and Hindi Cinema', *Tasveer Ghar*, June 2007. (available online:

https://bit.ly/3XASA75; last accessed: 16 February 2023).

18 My comments about Pakistan are mere observations of a casual Indian visitor, being used here to illustrate some basic points. A serious research into these areas may reveal much more.

19 Motilal Jotwani, *Sufis of Sindh* (Delhi: Publications Division, 1986), p. 166.

20 Jurgen Wasim Frembgen, *The Friends of God, Sufi Saints in Islam: Popular Poster Art from Pakistan* (Karachi: Oxford University Press, 2006).

21 Nazir Ahmad Chaudhry, *Basant: A Cultural Festival of Lahore* (Lahore: Sang-e-Meel Publications, 2001). Originally published in Urdu as *Basant: Lāhaur kā ṣaqāfatī tahvār* (Lahore: Sang-e-Meel Publications, 2001).

22 I saw a news item about the cutting of a giant cake in the shape of a mosque in Islamabad—the event was preceded by prayers by local clerics who were also among those who consumed the cake.

23 Yousuf Saeed, 'Fled is that Music' in Ira
 Pande (ed.), *The Great Divide, India and
 Pakistan* (New Delhi: HarperCollins, 2009),
 pp. 238–49. See also *Khayal Darpan: A
 Mirror of Imagination*, a documentary film
 directed and produced by Yousuf Saeed (New
 Delhi: Ektara India, 2006).

24 Richard Covington, 'Masterpieces to Go: The
 Trucks of Pakistan', *Saudi Aramco World*
 56(2) (March–April 2005) (available online:
 https://bit.ly/3EdGGct; last accessed: 16
 February 2023).

25 Joanna Kirkpatrick and Kevin Bubriski,
 'Transports of Delight: Ricksha Art of
 Bangladesh', *Saudi Aramco World* 45(1)
 (January–February 1994) (available online:
 https://bit.ly/3Is6Tqc; last accessed: 16
 February 2023).

26 I have seen at least one Indian portrait,
 drawn by H. R. Raja for a calendar, of Indira
 Gandhi along with the Rani of Jhansi in her
 typical horse-riding pose going for war. All
 around Indira, one sees Indian soldiers
 shooting at warplanes that have Pakistani

flag inscribed on them—some of them falling to Indian missiles (found in the Priya Paul Collection of Popular Art).

27 Iftikhar Dadi, 'Political Posters in Karachi, 1988–1999', *South Asian Popular Culture* 5(1) (April 2007): 11–30; here, p. 20.

28 The subject of Babri mosque's demolition has also been dealt with by Indian Muslims, mostly through the Urdu press, but hardly in any poster. One rare poster I saw in someone's house in Delhi shows the design of new green mosque that Muslims hope to build at the site of demolition.

29 *Suchi Patra* [Price list] (S. S. Brijbasi & Sons, 1933), p. 12; has particulars of various images, including *Musalman maqbaron ki tasveeren* [Pictures of Muslim shrines].

30 Iftikhar Dadi, 'Miniature Painting as Muslim Cosmopolitanism', *ISIM Review* 18(1) (Autumn 2006): 52–53.

31 Find out more here: https://mayapurigroup.com/about-us/

32 See a short video featuring these: Ektara India, 'Hindu religious books in Urdu - a forgotten legacy' (Yousuf Saeed dir. and ed.), YouTube (22 January 2016) (available online: https://youtu.be/gcPsE6uvxw8; last accessed: 16 February 2023).

33 Shamsuddoza Sajen, 'How Partition impacted the Dhaka book trade', *The Daily Star*, 19 August 2022 (available online: https://bit.ly/3HWF6wM; last accessed: 16 February 2023).

34 Yousuf Saeed, 'Eid Mubarak: Cross-cultural Image Exchange in Muslim South Asia' in Christine Brosius, Sumathi Ramaswamy and Yousuf Saeed (eds), *Visual Homes, Image Worlds: Essays from Tasveer Ghar* (New Delhi: Yoda Press, 2015).

35 Yousuf Saeed, 'Ishtihar Tasveeren: Visual Culture of Early Urdu Magazines', *ArtConnect* 7(2) (July–December 2013): 4–20. Also available online in *The Guftugu Collection*: https://bit.ly/3S5rfZD (last accessed: 16 February 2023).

36 See the 1947 Partition Archive (available online: 1947partitionarchive.org; last accessed: 31 March 2023).

37 See the Partition Museum, Town Hall, Amritsar (website: partitionmuseum.org; last accessed: 31 March 2023).

FURTHER READING

CORREIA, Alice, and Natasha Eaton (eds). 'To Draw the Line: Partitions, Dissonance, Art—A Case for South Asia', special issue, *Third Text* 31(2–3) (2017).

GUPTA, Vivek, and Aparna Kumar. 'How partition divided a centuries-old manuscript between India and Pakistan—and continues to plague the region's heritage'. *The Art Newspaper*, 12 August 2022. Available online: https://bit.ly/3m9zp7J (last accessed: 6 April 2023).

'Journey of a painting in the chaos of Partition'. *The Tribune*, 22 August 2020. Available online: https://bit.ly/3Kik90e (last accessed: 6 April 2023).

KUMAR, Aparna Megan. 'Partition and the Historiography of Art in South Asia'. PhD dissertation. University of California, Los Angeles, 2018. Available online: https://bit.ly/417nsOI (last accessed: 6 April 2023).

SHARMA, Ekatmata. 'Revisiting Partition through art'. *Art Culture Festival*. Available online: https://bit.ly/40RV5og (last accessed: 6 April 2023).

SHARMA, Manoj. 'Sprinkled across Delhi, shops hold on to family history, pre-Partition legacy'. *Hindustan Times*, 7 September 2022. Available online: https://bit.ly/3zyaTAq (last accessed: 6 April 2023).

'A Visual History of the Partition of India: A Story in Art'. *The Heritage Lab*, 14 December 2017. Available online: https://bit.ly/3ZOeipn (last accessed: 6 April 2023).

ZAIDI, Saima (ed.). *Mazaar, Bazaar: Design and Visual Culture in Pakistan*. Karachi: Oxford University Press, 2009.

ILLUSTRATION SOURCES AND CREDITS

FIGURES

1. Ajanta Art Calendar Mfg. Co., Delhi/Madras, *c.* 1930. Courtesy of Erwin Neumayer and Christine Schelberger.

2. Delhi Calendar Mfg. Co., 1941. Courtesy of the Priya Paul Collection, New Delhi.

3. Ajanta Art Calendar Mfg Co., Madras, *c.* 1940. Courtesy of the Priya Paul Collection, New Delhi.

4. Publisher unknown. Calcutta, 1942. Courtesy of the Priya Paul Collection, New Delhi.

5. Shyam Sundar Lal Agarwal, Kanpur, 1945. Courtesy of the Priya Paul Collection, New Delhi.

6. Print by Das Gupto. 1949. Courtesy of Erwin Neumayer and Christine Schelberger.

7. Publisher unknown. *c.* 1940. Courtesy of the Priya Paul Collection, New Delhi.

8. Ajanta Art Calendar Mfg., *c.* 1940. Courtesy of the Priya Paul Collection, New Delhi.

9. Publisher unknown. *c.* 1940. Courtesy of the Priya Paul Collection, New Delhi.

10. Publisher unknown. 2004. From the author's own collection.

11. Print by Sarwar Khan. *c.* 2004. From the author's own collection.

12. Print by Sarwar Khan. *c.* 2004. From the author's own collection.

13. Publisher unknown. *c.* 1990. Courtesy of Iftikhar Dadi.

14. Publisher unknown. *c.* 1990. Courtesy of the State Museum of Ethnology, Munich via Jürgen Wasim Frembgen.

15. Advertisement by Aror Bans Press, Lahore. Published in *Aalamgir*, 1930. From the author's own collection.

16. Originally produced as a Tucks Postcard, later reused by Bombay Press for an Eid card, *c.* 1930. Courtesy of Omar Khan.

To see the images in this book in colour, scan the following QR code: